BIOGRAPHIC
DEGAS

BIOGRAPHIC
DEGAS

KATIE GREENWOOD

AMMONITE
PRESS

First published 2017 by
Ammonite Press
an imprint of Guild of Master Craftsman Publications Ltd
Castle Place, 166 High Street, Lewes, East Sussex, BN7 1XU,
United Kingdom

Text © Katie Greenwood, 2017
Copyright in the Work © GMC Publications Ltd, 2017

ISBN 978 1 78145 303 2

A catalogue record for this book is available from the
British Library.

Publisher: Jason Hook
Concept Design: Matt Carr
Design & Illustration: Matt Carr & Robin Shields
Editor: Jamie Pumfrey
Consultant Editor: Dr Grant Pooke
Picture Research: Katie Greenwood

Colour reproduction by GMC Reprographics
Printed and bound in Turkey

Picture credits:
AKG Images/Sotheby's: 44, 88. Alamy/Classicpaintings: 39; GL Archive: 22R;
Granger Historical Picture Archive: 47TR; Heritage Image Partnership Ltd: 59L, 64.
Bibliothèque nationale de France: 23R. Brooklyn Museum: 54B. Dumbarton Oaks,
House Collection, Washington, D.C.: 61. Getty Images/De Agostini Picture
Library: 72; Fine Art: 68; Leemage: 23L, 60. J. Paul Getty Museum. Digital image
courtesy of the Getty's Open Content Program: 45, 55BC. Los Angeles County
Museum of Art: 73, 84B. The Metropolitan Museum of Art: 47BL, 47BR, 56L, 56R,
57TL, 57TR, 57CR, 57BL, 57BR, 65, 70TR. National Gallery of Art, Washington,
D.C.: 47TL, 48, 55TL, 55BL, 55BR, 59R, 66, 67, 74, 76, 84T; Yale University Art Gallery:
71TR; Published with the permission of the Conservation Department of the National
Gallery of Art, Washington, D.C.: 75.

CONTENTS

ICONOGRAPHIC 06

INTRODUCTION 08

01: LIFE 11

02: WORLD 35

03: WORK 51

04: LEGACY 77

BIOGRAPHIES 92

INDEX 94

ICONOGRAPHIC

WHEN WE CAN RECOGNIZE AN ARTIST BY A SET OF ICONS, WE CAN ALSO RECOGNIZE HOW COMPLETELY THAT ARTIST AND THEIR WORK HAVE ENTERED OUR CULTURE AND OUR CONSCIOUSNESS.

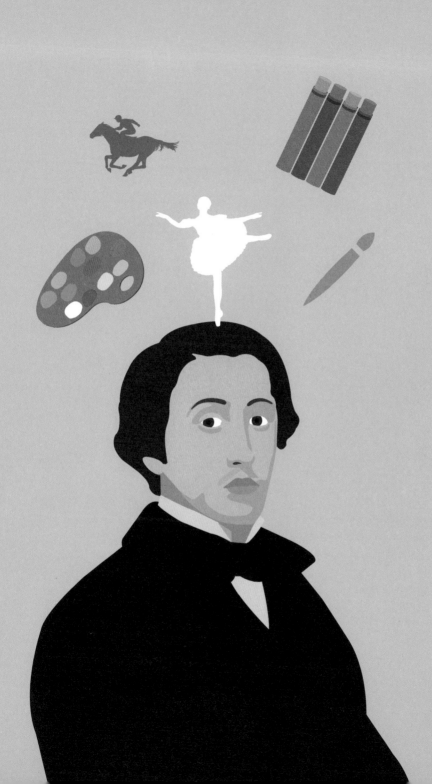

INTRODUCTION

Known as one of the most influential and enigmatic of all Impressionist artists, Edgar Degas is famous for his portrayal of dancers and Parisian society. A highly skilled draughtsman, he studied the art of antiquity and the Renaissance masters. He possessed a deep reverence for the past, yet he was a great experimenter at the forefront of an avant-garde group who would change the way people saw the world in the 19th century. As a member of the haute bourgeoisie, Degas had some old-fashioned views, but his art was revolutionary.

Degas rose to prominence as a leading member of the circle of artists that included Claude Monet and Pierre-Auguste Renoir. These artists, through a series of independent exhibitions, sought to break away from the *Salon de Paris* – the large, highly selective annual art event that was the established route to exposure – and present modern life as they saw it. Degas always stood slightly apart from his contemporaries and disliked being identified as an Impressionist, preferring to be thought of as independent. Though he shared some similar techniques and objectives with these artists, he differed significantly in his approach.

"A PAINTING REQUIRES A LITTLE MYSTERY, SOME VAGUENESS, SOME FANTASY. WHEN YOU ALWAYS MAKE YOUR MEANING PERFECTLY PLAIN YOU END UP BORING PEOPLE. EVEN WORKING FROM LIFE, YOU MUST COMPOSE."

—Edgar Degas, quoted in *Memories of Degas* by Pierre-Georges Jeanniot, 1933

Intellectually, Degas possessed a razor-sharp wit; he was a master of conversation and was capable of being scathing and cruel, both about others and himself. Riddled with anxiety and self-doubt, he suffered from a deep melancholia that grew as he aged, intensified by loneliness and a degenerative eye disease that would leave him almost blind. However, he could also be immensely generous and supportive, loyal to his family and closest acquaintances – the sad exception being childhood friend Ludovic Halévy following the Dreyfus Affair.

At the beginning of his career Degas emulated his idols, particularly Jean-Auguste-Dominique Ingres, painting portraiture and scenes from history. But he would soon make the decision to represent modern life in motion, with his works becoming increasingly expressive as he neared the end of his life. He was a master of line, colour and composition who drew from several influences, among them Japanese art, to create a style that was distinctively his own.

Degas was a private man who largely shunned fame. Believing that the artist should live a solitary life he remained a bachelor and dedicated himself completely to his art, yet he later expressed regret at his decision to do so. Lacking any intimate relationship, it seems that as an artist he was driven by an overwhelming emotional need: obsessive in exploring certain themes – ballet dancers, horse racing, café culture, women shown at work and in their private moments – he revisited the same motifs over and over again in a variety of media.

Today Degas is celebrated for his originality, but there is a cloud over his image. Some of his work has been viewed as misogynistic, representing women in a raw physical state (far from the chocolate-box prettiness favoured by some of his fellow artists), and his anti-Semitism has served to alienate him from some modern audiences and critics. Looking at his life and art presents many contradictions, but it is his personal idiosyncrasies set against a prolific output, raw talent and stylistic innovation that makes Degas uniquely Degas.

"I, MARRY? OH, I COULD NEVER BRING MYSELF TO DO IT. I WOULD HAVE BEEN IN MORTAL MISERY ALL MY LIFE FOR FEAR MY WIFE MIGHT SAY, 'THAT'S A PRETTY LITTLE THING,' AFTER I HAD FINISHED A PICTURE."

—Edgar Degas, quoted in *Degas: An Intimate Portrait* by Ambroise Vollard, 1927

EDGAR
DEGAS

01
LIFE

"I REALLY HAVE SOME LUGGAGE IN MY HEAD. IF ONLY THERE WERE INSURANCE COMPANIES FOR THAT AS THERE ARE FOR SO MANY THINGS HERE, THERE'S A BALE I SHOULD INSURE AT ONCE."

—Edgar Degas, letter to James Tissot, New Orleans, 1873

HILAIRE-GERMAIN-EDGAR DEGAS

was born on 19 July 1834 in the 9th arrondissement of Paris, France

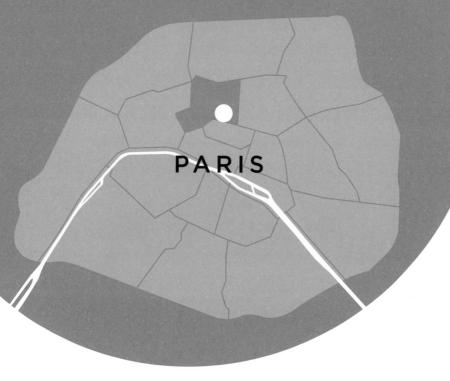

PARIS

Born into a wealthy banking family at 8 rue St Georges, Edgar was raised in a climate of intellectual and cultural aspiration. The 9th arrondissement, situated on the Right Bank, was the preferred location of the haute bourgeoisie. Its streets were lined with refined Neoclassical buildings – including the favoured homes of financiers and property brokers – that earned the district the nickname *Nouvelle Athènes* ('The New Athens'). Degas would live in the district for his entire life as an artist.

Also born in the 9th ▶
arrondissement: **Claude Monet**
(1840–1926), fellow painter whose
work *Impression, Sunrise* would
give its name to Impressionism

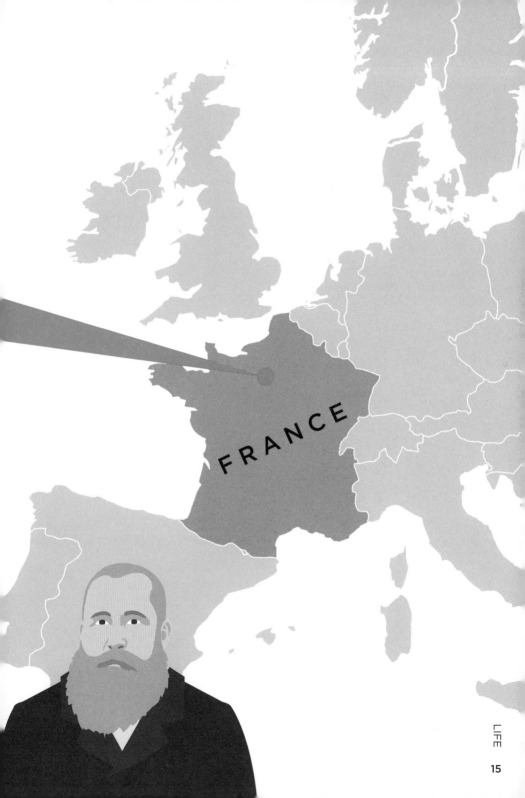

THE WORLD IN
1834

LONDON, ENGLAND

On 14 August, the new Poor Law is passed, requiring able-bodied 'paupers' to enter the workhouse in exchange for food and clothes.

VERMONT, USA

Sandpaper patent is granted on 14 June to Isaac Fischer, Jr. in Springfield, Vermont.

NEW YORK CITY, USA

Anti-abolitionist riots rock New York City from 7 to 10 July.

DORSET, ENGLAND

The Tolpuddle Martyrs are sentenced to seven years in the Australian penal colony for the formation of a trade union.

The world into which Degas was born was experiencing rapid change. Following the Western Enlightenment, the rise of liberal ideology continued to produce social reform, such as the gradual abolition of slavery, and paved the way for political revolution. But there was also conflict, especially around workers' rights in the face of increasing industrialization.

Paris had been illuminated by gas street lighting in the previous decade and was a centre of modernity on the cusp of a period of huge expansion. During Degas's lifetime it would be physically transformed through radical town planning and a soaring population, while new ideas in the arts and the growth of middle-class leisure would change the city into the cultural capital of the 19th century.

THE WEST INDIES

On 1 August, slavery is abolished throughout most of the British Empire, freeing 750,000 slaves in the West Indies, 20,000 in Mauritius and 40,000 in South Africa. India and Ceylon, territories controlled by the East India Company, are exceptions.

LONDON, ENGLAND

On 16 October, the Palace of Westminster catches fire.

NAPLES, ITALY

On 23 August, Mount Vesuvius erupts near Naples, birthplace of Degas's father and home to many of his relatives.

PALESTINE

The Peasants' Revolt against Egyptian conscription and taxation begins in May.

SOUTH AUSTRALIA

The South Australia Act permits the establishment of a British colony on 15 August.

Giovanna-Aurora-Teresa Freppa
Born: 1783, Livorno, Italy
Died: 1841, Naples, Italy

René-Hilaire De Gas
Born: 1770, Orleans, France
Died: 1858, Naples, Italy

FATHER
Laurent-Pierre-Auguste-Hyacinthe De Gas
Born: 1807, Naples, Italy
Died: 1874, Naples, Italy

Hilaire-Germain-Edgar Degas
Born: 1834, Paris, France
Died: 1917, Paris, France

Achille De Gas
Born: 1838, Paris, France
Died: 1893, Paris, France

▲ *Portrait of Hilaire de Gas*
Edgar Degas
Oil on canvas, 1857
21 x 16 inches (53 x 41 cm)

THE DEGAS DESCENDANTS

Degas's grandfather Hilaire is said to have fled from France during the revolution, but he quite probably fled his creditors and not the guillotine. He became a banker in the city of Naples, married well and flourished, and in 1825 sent his son Auguste to Paris to set up a branch of the family business. Auguste changed his name to De Gas to imitate nobility (something Edgar would reverse by the age of 30) and met Célestine Musson, a Creole from New Orleans whose family had become rich through the cotton industry. They married at the church of Notre-Dame-de-Lorette on 14 July 1832 and had five children, but Célestine sadly died when Edgar, her oldest child, was only 13. His father Auguste and grandfather Hilaire were the primary influences on Degas's early life, instilling in him a love of music and the arts, and allowing him the freedom to pursue his passion without the financial constraints faced by many of his contemporaries.

**Jean-Baptiste-Étienne-
Germain Musson**
Born: 1787,
Port-au-Prince, Haiti
Died: 1853, Mexico

Marie-Céleste Rillieux
Born: 1794, New Orleans,
Louisiana
Died: 1819, New Orleans,
Louisiana

MOTHER

Marie-Célestine Musson
Born: 1815, New Orleans, Louisiana
Died: 1847, Paris, France

Jean-Baptiste-René De Gas
Born: 1845, Paris, France
Died: 1921, Paris, France

Marie-Thérèse Havie De Gas
Born: 1840, Naples, Italy
Died: 1912, Naples, Italy

Laure-Marguerite De Gas
Born: 1842, Paris, France
Died: 1895, Buenos Aires,
Argentina

BECOMING AN ARTIST

The early years of Degas's life were privileged and exciting ones, albeit tinged with sadness following the death of his mother. He attended a renowned school, the Lycée Louis-le-Grand, where he formed lifelong friendships with fellow students Paul Valpinçon, Henri Rouart and Ludovic Halévy and also established his reputation as a skilled draughtsman.

Degas decided to pursue art as his vocation at the age of 21 after a meeting with Jean-Auguste-Dominique Ingres. The years that followed saw him travel extensively in Italy, exhibit at the Salon, find his own style and connect with a circle of avant-garde artists who would become known as the Impressionists.

1855

Meets the artist Jean-Auguste-Dominique Ingres and decides to pursue art instead of law.

Admitted to the École des Beaux-Arts under Louis Lamothe, though will never finish his studies there.

Begins work on portraits of himself and his family.

1853

Graduates from the Lycée Louis-le-Grand in March and receives permission to copy paintings at the Louvre in April. Enrols at law school in November.

Georges-Eugène Haussmann begins his renovations of Paris under Napoleon III.

1847

Edgar's mother Célestine dies. Edgar is only 13 years old.

1834

Edgar Degas is born on 19 July in the 9th arrondissement of Paris.

1845

Attends boarding school at the Lycée Louis-le-Grand.

1856

Travels to Italy where he will spend the next three years studying Renaissance and Classical masterpieces and making portraits of his extended family.

1858

His grandfather Hilaire dies.

1859

Returns from Italy and sets up a studio at rue de Laval, where he paints portraits and begins several history paintings.

1862

Meets the artist Édouard Manet whilst copying *Infanta Margarita* by Velázquez at the Louvre.

1863

Avant-garde works rejected by the Salon are exhibited at the *Salon des Refusés*, which includes pieces by Manet and James Abbott McNeill Whistler.

1868

Frequents Café Guerbois, meeting place of an avant-garde artistic circle that includes Renoir and Monet.

Exhibits *Portrait of Mlle Fiocre in the Ballet 'La Source'* at the Salon – his first major work to feature a dancer.

1867

Visits the International Exposition and is interested in the Japanese woodblock prints and English painters he sees there.

1866

Exhibits *Scene from the Steeplechase: The Fallen Jockey* at the Salon, signalling a turn towards modern subjects.

1865

Exhibits at the Salon for the first time with his painting *Scene of War in the Middle Ages*.

1855

MEETING THE MASTER

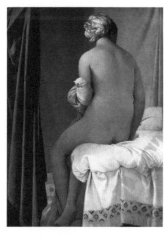

▲ *The Bather* (also known as *The Valpinçon Bather*)
Jean–Auguste-Dominique Ingres
Oil on canvas, 1808
57 x 38 inches (146 x 97 cm)

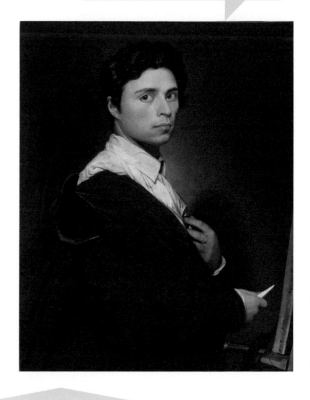

Self-Portrait at the Age of 24
Jean-Auguste-Dominique Ingres
Oil on canvas, 1804, 30 x 25 inches (77 x 63 cm)

Degas met the Neoclassical painter Jean-Auguste-Dominique Ingres in 1855 via the collector Édouard Valpinçon – the father of Degas's school friend Paul. He learned from him the importance of line and carefully studied form.

> ## "I DO SOME PAINTING, I AM JUST STARTING OUT, AND MY FATHER, WHO IS A MAN OF TASTE AND AN ART LOVER, IS OF THE OPINION THAT I AM NOT A TOTALLY HOPELESS CASE."
>
> **—Degas to Ingres, 1855**

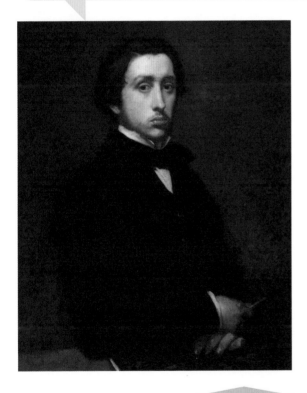

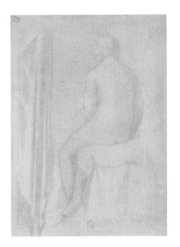

▲ **Copy after *The Bather* by Ingres**
Edgar Degas
Graphite on paper

Portrait of the Artist
Edgar Degas
Oil on paper, laid on canvas, 1855, 26 x 32 inches (65 x 82 cm)

The young Degas revered and emulated Ingres more than any other artist. Here, he mimics the artist's pose in *Self-Portrait at the Age of 24* within his own self-portrait, painted the year they met.

AN ITALIAN EDUCATION

Degas lived in Italy for nearly three years from the age of 22, staying with family in both Naples and Florence and meeting lifelong friend Gustave Moreau while in Rome. On his travels he would make many copies of Classical and Renaissance artworks and also studies of the people and landscape, filling 28 sketchbooks.

He painted scenes from history and produced several family portraits including laying the groundwork for *The Bellelli Family* (1858–67), considered by many to be his earliest masterpiece. Having escaped the formal training of the École des Beaux-Arts, he continued his education on his Italian adventure, studying the masters, line and form – the very foundation of his work.

JULY 1856 **01** NAPLES

Arrives from Marseilles and stays at the Palazzo Pignatelli di Monteleone with his grandfather Hilaire and aunts Rosa and Stefania. Paints portraits of his family and studies the collection of the National Museum, which includes Roman murals and works by Renaissance masters such as Titian. Degas journeys into the surrounding countryside and travels by boat to

02 SORRENTO

OCTOBER 1856 **03** CIVITAVECCHIA **04** ROME

Travels by boat via the port of Civitavecchia to Rome, where he attends the academy at the Villa Medici in the evenings. Studies works including *Saint Jerome in the Wilderness* (c. 1482) by Leonardo da Vinci in the Vatican and mosaics attributed to Giotto in St Peter's Basilica. The Villa Borghese and the Roman Forum also provide points of reference. Starts to sketch street scenes.

JULY 1857 **05** TERRACINA **06** FONDI **07** GAETA

Leaves Rome and travels back to Naples, stopping en route.

AUGUST 1857 **08** NAPLES

Stays at his grandfather's villa in Capodimonte, where he paints two portraits of him.

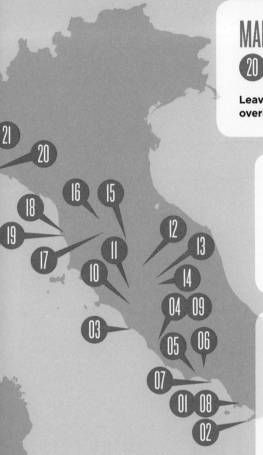

MARCH 1859 ⑲ LIVORNO ⑳ GENOA ㉑ TURIN

Leaves Florence and makes his way home overland, arriving in Paris in early April.

MARCH 1859 ⑰ SIENA ⑱ PISA

In Pisa, Degas and friend Gustave Moreau copy the Benozzo Gozzoli frescoes in the Campo Santo.

AUGUST 1858 ⑯ FLORENCE

Stays with his aunt Laura at the Bellelli apartment, where he makes preparatory sketches for *The Bellelli Family*. His grandfather Hilaire dies in Naples on 31 August but perhaps strangely Degas does not return there. Studies the Venetian masters including Veronese and Giorgione, and copies works in the Uffizi Gallery.

OCTOBER 1857 ⑨ ROME

Returns to Rome and copies works in the Sistine Chapel and Capitoline Museums. Starts work on *David and Goliath* and paints *A Roman Beggar Woman*, as well as studying the etchings of Claude Lorrain in the Corsini Gallery.

SUMMER 1858

⑩ VITERBO ⑪ ORVIETO ⑫ PERUGIA ⑬ ASSISI ⑭ SPELLO ⑮ AREZZO

PROLIFIC OUTPUT

Napoleon III declared war on Prussia the day of Degas's 36th birthday. After he enlisted in the National Guard, a fault was discovered in his right eye during a rifle training exercise – signalling the degenerative retinal disease that would haunt his life. Following his stint in the army he escaped to New Orleans to stay with his mother's side of the family, discovering an industrialized modern America.

Paris, too, was changing rapidly, and on his return he embarked on a period of prolific output driven by visits to the pleasures the modern city had to offer: the opera, the ballet, concerts and cafés. During his middle age he exhibited in seven of the eight Impressionist Exhibitions. His work entered a museum collection and he dedicated his life to his art, foregoing marriage and remaining a bachelor.

1870

Enlists in the National Guard at the start of the Franco-Prussian War, serving with Manet in the volunteer artillery under his friend Henri Rouart.

Exhibits *Madame Camus* at the Salon.

1871

France surrenders and the Paris Commune is established.

Visits London; sees the exhibition of French artists, organized by the art dealer Paul Durand-Ruel.

1876

Participates in the Second Impressionist Exhibition at Galerie Durand-Ruel.

1875

Opening of the Palais Garnier, the new home of the Paris Opera.

1874

His father Auguste dies and his brother René's debt becomes apparent.

Exhibits at the First Impressionist Exhibition, held at the former studio of the photographer Nadar.

1873

Paints *A Cotton Office in New Orleans*, returning to Paris in March.

Forms 'The Anonymous Society of Painters, Sculptors, Engravers, etc'. The group would become known as the Impressionists.

German troops leave France and the Long Depression hits Europe and North America (1873–96).

1872

Durand-Ruel buys three Degas paintings directly from the artist.

Travels to New Orleans with brother René, aboard the *Scotia*.

1877

Exhibits works, including *L'Absinthe* and *L'Etoile,* at the Third Impressionist Exhibition.

He feels a financial burden for the first time and his health worsens.

1878

The Degas family becomes bankrupt.

The Musée de Beaux-Arts de Pau purchases *A Cotton Office in New Orleans* for 2,000Fr. It is his first time in a public collection. He also exhibits in the United States for the first time.

1879

Exhibits works, including *Miss La La at The Cirque Fernando,* at the Fourth Impressionist Exhibition.

Meets the artist Mary Cassatt.

1880

Exhibits at the Fifth Impressionist Exhibition, including the painting *Portraits at the Stock Exchange.*

Begins to reap financial rewards from his art.

1881

Exhibits the sculpture *Little Dancer Aged Fourteen* at the Sixth Impressionist Exhibition, causing a scandal, and clashes with Gustave Caillebotte over the future of the group.

1886

Exhibits 23 works in the First American Impressionist Exhibition in New York.

The Eighth, and final, Impressionist Exhibition is held in Paris; he exhibits a series of nudes.

1885

Acquires his first painting by Ingres.

Meets with Walter Sickert and Paul Gauguin in Dieppe.

1883

Rejects a solo exhibition from Durand-Ruel, but seven works are shown at Dowdeswell & Dowdeswell in London.

1882

Refuses to participate in the Seventh Impressionist Exhibition.

Visits his friends the Halévys in Normandy.

RELATIONSHIPS WITH WOMEN

Degas's bachelorhood, at a time when it was seen as a sign of social degeneracy, was the source of much speculation. There is little evidence that he ever slept with a woman despite being obsessive about studying the female form. While in Italy he wrote of wanting to find "a good little wife" but seemingly abandoned this desire to dedicate his life to his art. He would later write about his regret at celibacy.

Some of his work reveals anxiety about relationships between the sexes and his nudes have been accused of being cruel and voyeuristic, but in his intimate portraits he shows women as individuals, capturing subtle emotions with skill. He had close friendships with several female artists within the Impressionist circle – particularly Mary Cassatt – and greatly encouraged them in their work.

SISTER

Thérèse De Gas
Married their cousin
Edmondo Morbilli

MOTHER

Célestine Musson
Died when he was 13

SISTER

Marguerite De Gas
She is said to have
been his
favourite model

NIECE

Jeanne Fèvre
Marguerite's
daughter, cared for
him in old age

**COUSIN AND
SISTER-IN-LAW**

Estelle Musson
Wife of his
brother René

AUNT

Laura Bellelli
Edgar painted her
family while he
was in Florence

Mary Cassatt
Degas's closest
female friend

Rose Caron
Degas greatly
admired her grace

Marie Braquemond
Degas, along with
Monet, became
her mentor

Suzanne Valadon
Shared mutual
admiration and
friendship

Berthe Morisot
Degas was a loyal
friend to her and
her family

Marie Sanlaville
Principal ballerina
at the Paris Opera

Marie van Goethem
'Petit rat', the subject
of *Little Dancer
Aged Fourteen*

Sabine Neyt
Housekeeper, she
also modelled
for Degas

**Blanche &
Suzanne Mante**
Ballet students
whose father was
in the Paris Opera
orchestra

KEY family staff artist dancer singer

LIFE

RENOWN AND ISOLATION

1887

Stops exhibiting in group shows.

Begins to form own art collection in earnest.

1895

His sister Marguerite dies.

Purchases *The Day of the God* by Paul Gauguin, alongside works by Van Gogh, Cézanne and Delacroix.

Experiments in photography with portraits of his friends the Halévys.

1896

The Caillebotte bequest places 7 of his works in the Musée de Luxembourg.

1889

The Eiffel Tower is completed.

1894

The Dreyfus Affair erupts. France is divided and he supports the verdict.

1897

His anti-Semitism begins to alienate him from his liberal and Jewish friends, including the Halévys.

1892

His first solo exhibition is held at Galerie Durand-Ruel.

Wears a strange optical device to strengthen his eyesight.

1893

His brother Achille dies.

1905

Exhibits 35 works at an exhibition organized by Durand-Ruel at the Grafton Galleries, London, alongside Cézanne, Boudin and the Impressionists.

1910
Stops cutting his hair and trimming his beard.

1911
His second and final solo exhibition to be held during his lifetime opens at the Fogg Museum at Harvard University.

1912
Forced to leave the apartment he has lived in since 1890. The move depresses him and he no longer works.

His sister Thérèse and friend Henri Rouart both die.

Rouart's art collection is sold and *Dancers at the Barre* sells for a record 478,000Fr.

1908
His estranged friend Ludovic Halévy dies.

1913
Mary Cassatt writes that Degas is a physical wreck.

1916
Becomes bedridden.

1906
Dreyfus is exonerated.

1914
World War I breaks out.

1917
Dies on 27 September, aged 83, at his home.

The last 20 years of Degas's life were bittersweet. His work became more revered and valuable than ever before, and stylistically looser and brighter – ironically more Impressionist than when he was exhibiting with the Impressionists. He found excitement in experiments with photography, monotype and sculpture, and in amassing his own vast art collection.

Old age weighed heavily upon the artist. Isolated by the death of several close friends, the lack of an intimate relationship and his anti-Semitic views, Degas found himself increasingly alone. His eyesight and health rapidly deteriorated, he became ever more reclusive, morose and regretful. When he was forced to move from his beloved apartment in 1912, he stopped working. He died five years later.

THE DREYFUS AFFAIR

PRO-DREYFUS (DREYFUSARD)

Alfred Dreyfus (1859–1935) was a Jewish artillery captain in the French army. In 1894 he was convicted of passing military secrets to the Germans, after a French spy in the German embassy found a ripped-up letter supposedly written in his hand. He was found guilty of treason and sentenced to life imprisonment, and was subjected to calls of "Death to Judas, death to the Jew." In 1896, evidence was uncovered that pointed to a Major Esterhazy being the real traitor.

Esterhazy was court-martialled in 1898 but found not guilty, and subsequently fled France – leading to calls of a military cover-up from Dreyfus supporters such as Émile Zola. Dreyfus was court-martialled a second time in 1899, pardoned a few days later and finally exonerated in 1906. The Dreyfus Affair deeply divided France and stirred prejudice. It highlighted Degas's anti-Semitic views, estranging him from many of his circle, including lifelong Jewish friend Ludovic Halévy.

ÉMILE ZOLA

CLAUDE MONET

CAMILLE PISSARRO

MARCEL PROUST

Dreyfus was imprisoned ▶
on Devil's Island, off
French Guiana

EDGAR DEGAS

PAUL CÉZANNE

PAUL VALÉRY

HENRI ROUART

ANTI-DREYFUS
(ANTI-DREYFUSARD)

THE DEATH OF DEGAS

DATE:
27 SEPTEMBER 1917

AGE:
83

FUNERAL:

The funeral was attended by Claude Monet, Mary Cassatt, Louise Halévy and Ambroise Vollard.

In accordance with his wishes, no speeches were made.

CAUSE OF DEATH:
BRAIN ANEURYSM

EPITAPH:
"HE LOVED DRAWING VERY MUCH"

ALSO BURIED AT MONTMARTRE:

Gustave Moreau, painter (1826–98), Alexandre Dumas, writer (above) (1802–70), Hector Berlioz, composer (1803–69)

FAMILLE de GAS

RESTING PLACE:

Degas died at 6 Boulevard de Clichy, Paris, and is buried in the family vault, in the city's Montmartre Cemetery.

02
WORLD

"... EVEN THIS HEART OF MINE HAS SOMETHING ARTIFICIAL. THE DANCERS HAVE SEWN IT INTO A BAG OF PINK SATIN, SLIGHTLY FADED LIKE THEIR DANCING SHOES."

—Edgar Degas, letter to Paul-Albert Bartholomé, 17 January 1886

COTTONING ON

Degas travelled in 1872 to New Orleans, where he escaped the echoes of war and discovered a modern, industrialized America. He stayed for five months, embarking on a series of paintings featuring his mother's side of the family and the cotton trade through which they had amassed their fortune. *A Cotton Office in New Orleans* is set in the commercial premises of the Musson family and represents 14 men at work.

The painting had a commercial purpose: Degas had an eye on the British art market and hoped that the industrial subject would attract a commission from a mill owner in Manchester, via the dealer Thomas Agnew. In a letter to his friend James Tissot, he wrote: "If ever a cotton manufacturer wanted a painter, I would be his man." But who are the men in the painting?

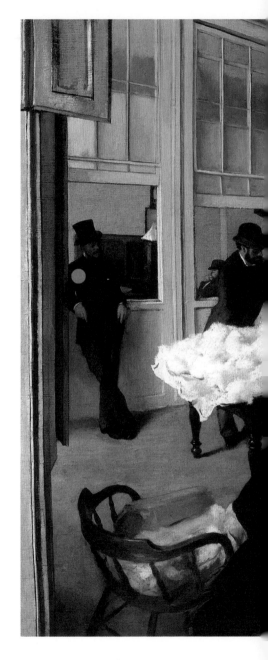

● **Michael Musson (uncle)**

● **René De Gas (brother)**

● **Achille De Gas (brother)**

● **John Livaudais (accountant)**

● **William Bell (Musson's son-in-law)**

● **James Prestridge (Musson's partner)**

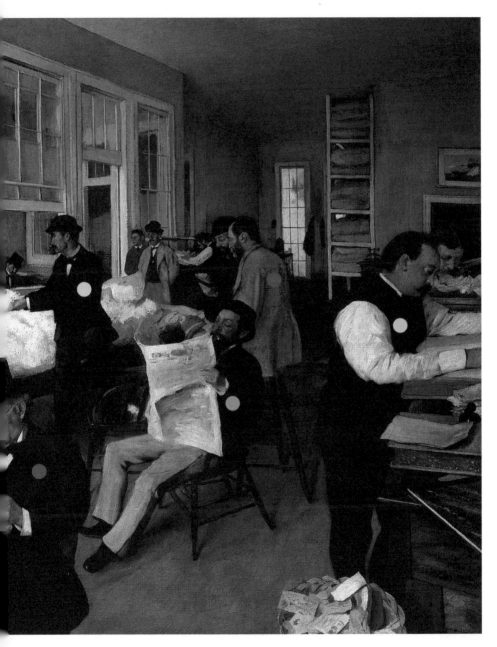

▲ *A Cotton Office in New Orleans*
Edgar Degas
Oil on canvas, 1873
29 x 36 inches (73 x 92 cm)

1 CAFÉ GUERBOIS,
11 grand rue des Batignolles
(now 9 avenue de Clichy)
Original meeting place
for Manet, Degas and the
Impressionist circle

2 CAFÉ DE LA
NOUVELLE ATHÈNES,
9 place Pigalle
Favoured café of the
Impressionist group after
the Paris Commune

3 CAFÉ ROCHEFOUCAULD,
49 rue de La
Rochefoucauld
Café where artists, including
Degas, met their models

4 CHURCH OF NOTRE-
DAME-DE-LORETTE,
8 rue Choron
The church where Degas
was christened, and where
his parents married

5 MONTMARTRE CEMETERY,
20 avenue Rachel
Where Degas was buried

6 SALLE DE PELETIER,
rue le Peletier
Home of the Paris Opera 1821–73
until it was destroyed by fire

7 PALAIS GARNIER,
7 place de l'Opéra
Home of the Paris Opera from 1875

8 CAFÉ DES AMBASSADEURS,
1 avenue Gabriel
Restaurant and nightclub

9 ALCAZAR D'ETÉ,
8 avenue Gabriel
Café-concert venue

10 THÉÂTRE DES VARIÉTÉS,
7 Boulevard Montmartre
Theatre featured in Émile
Zola's novel *Nana*

11 CABARET LE RAT MORT,
7 place Pigalle
Rodolphe Salis' cabaret venue
after Le Chat Noir

12 CIRQUE FERNANDO,
63 Boulevard de Rochechouart
Circus where Degas made
many studies

DEGAS

40

DEGAS'S PARIS

Paris developed into a modern metropolis during Degas's lifetime. Exciting leisure venues were springing up around the city and by 1863 there were around 300 theatres providing both high- and low-brow entertainment. Degas lived in the 9th arrondissement and was surrounded by these new spectacles, which provided plentiful subject matter.

He sketched dancers at the ballet, singers at café-concerts and performers at the circus, with local brothels becoming the setting for a series of monotypes as well as a source of models (though there are no clues that he indulged in their pleasures). A burgeoning café culture also gave him the opportunity to converse and debate with like-minded artists and thinkers.

KEY

 CAFÉS

 RELIGIOUS SITES

 ENTERTAINMENT

 ART

 DEGAS'S HOMES

13 MUSÉE DE LOUVRE
Degas studied the work of his idols and copied the great masters here

14 HENNEQUIN, grand rue des Batignolles (now 11 Avenue de Clichy)
Shop supplying art materials

15 TASSET ET LHOTE, 31 rue Pierre Fontaine
Shop supplying art and photographic materials

16 ANZOLI, 4 rue de La Vieuville
Picture framer

17 35 BOULEVARD DES CAPUCINES
Location of the first Impressionist exhibition, former studio of the photographer Nadar

18 EDOUARD MANET'S STUDIO, 4 rue de St Pétersbourg

19 8 RUE ST GEORGES
Degas's birthplace

20 13 RUE DE LAVAL (renamed rue Victor-Massé in 1887)
His first home and studio 1859–72

21 77 RUE BLANCHE
Home and studio 1872–76

22 4 RUE FROCHOT
Home and studio 1876–77

23 50 RUE LEPIC
Home and studio 1877–82

24 21 RUE JEAN-BAPTISTE PIGALLE
Home and studio 1882–90

25 18 RUE DE BOULOGNE (now 23 rue Ballu)
Home and studio 1890

26 37 RUE VICTOR-MASSÉ
Home and studio 1890–1912

27 6 BOULEVARD DE CLICHY
His last home 1912–17, he never worked there

THE IMPRESSIONIST EXHIBITIONS

The group that had crystallized in the Café Guerbois showed their work independently of the Salon over the course of eight exhibitions, calling themselves 'The Anonymous Society of Painters, Sculptors, Engravers, etc'. Art critic Louis Leroy coined the label 'Impressionist' in a satirical response to Monet's painting *Impression, Sunrise*, shown in the first exhibition of 1874.

The term was adopted for the Third Exhibition in 1877, being called the 'Exhibition of Impressionists', much to the resistance of Degas who preferred to be identified as an independent. Degas clashed with other members – especially Gustave Caillebotte – over the group's future. He exhibited in all but one show, with participation by other key artists also fluctuating.

First Exhibition, 1874

ARTISTS: 30
TOTAL NUMBER OF WORKS: 165

ARTWORK BY:

- Gustave Caillebotte
- Mary Cassatt
- Paul Cézanne
- Edgar Degas
- Paul Gauguin
- Claude Monet
- Berthe Morisot
- Camille Pissarro
- Pierre-Auguste Renoir
- Alfred Sisley
- Other artists

Fifth Exhibition, 1880

ARTISTS: 19
TOTAL NUMBER OF WORKS: 232

Second Exhibition, 1876

ARTISTS: 20
TOTAL NUMBER OF WORKS: 252

Third Exhibition, 1877

ARTISTS: 18
TOTAL NUMBER OF WORKS: 230

Fourth Exhibition, 1879

ARTISTS: 15
TOTAL NUMBER OF WORKS: 246

Sixth Exhibition, 1881

ARTISTS: 13
TOTAL NUMBER OF WORKS: 170

**Seventh Exhibition, 1882
(Degas declined to exhibit)**

ARTISTS: 9
TOTAL NUMBER OF WORKS: 203

Eighth Exhibition, 1886

ARTISTS: 17
TOTAL NUMBER OF WORKS: 246

EDGAR DEGAS
1834–1917

YEARS LIVED:
83

WORKED:
57
(1855–1912)

Degas met Manet around 1862 when copying Velázquez's *Infanta Margarita* in the Louvre. Their relationship was built on mutual respect, but was tempestuous at times, with caustic remarks and accusations on both sides. At the beginning Degas was very much in the shadow of Manet, who was enjoying celebrity following his participation in the *Salon des Refusés*, but Degas caught up in acclaim by the early 1880s.

As well as differences, there were also several parallels between the life and work of the two artists – their privileged background, serving together in the Franco-Prussian War and above all pioneering modern life as a legitimate subject for high art.

INFLUENCES:
Ingres, Delacroix, Daumier

STYLE:
Straddled the movements of Realism and Impressionism

MOST EXPENSIVE PAINTING:
***Danseuse au Repos*, c. 1879, sold in 2008 for**

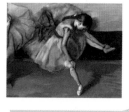

$37m

THEMES:
The ballet, café culture, horse racing, women at work, nudes

HEALTH:
Retinal degeneration began in his late-thirties, died from a brain aneurysm at the age of 83

MARRIAGES:
None

ÉDOUARD MANET
1832 – 1883

INFLUENCES:
Frans Hals, Velázquez, Goya

STYLE:
Straddled the movements of Realism and Impressionism

THEMES:
Urban bourgeois leisure, café culture, war, Parisian street scenes, nudes

MOST EXPENSIVE PAINTING:
Jeanne (Spring), 1881, sold in 2014 for

$65.1m

WORKED:
26
(1856 – 82)

YEARS LIVED:
51

HEALTH:
Pain and partial paralysis of his legs in his mid-40s, died at the age of 51 after amputation of left foot due to gangrene

MARRIAGES:
Married Suzanne Leenhoff, a Dutch piano teacher, in 1863. Her son Leon, born out of wedlock in 1852, was likely fathered by Manet but possibly by his brother

THE COLLECTOR

Degas amassed a huge collection of art that reflected his personal taste and the circles he moved in. He was obsessive about the artworks that filled his three-story apartment, which were either purchased or exchanged for his own work. He contemplated creating a public museum, but eventually gave up on the idea of a Musée Degas, and after his death the collection was sold at three sales in 1919 to worldwide collectors and museums. It was a newsworthy event, even during the First World War, that saw unprecedented prices.

20 PAINTINGS AND
88 DRAWINGS BY INGRES

8,000

THE ESTIMATED NUMBER OF WORKS IN DEGAS'S COLLECTION (INCLUDING HIS OWN)

1,605,075 francs ($320,000)

THE PROCEEDS FROM THE FIRST SALE, WHICH INCLUDED MAJOR PAINTINGS AND WORKS ON PAPER BY OTHER ARTISTS

13 PAINTINGS AND OVER 200 WORKS ON PAPER BY DELACROIX

82,000 francs

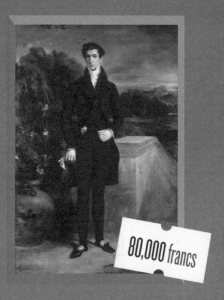

80,000 francs

▲ *Saint Ildefonso*
El Greco
Oil on canvas, c. 1603–14
44 x 26 inches (112 x 66 cm)
Purchased 1894, 2,000 francs

▲ *Louis-Auguste Schwiter*
Eugène Delacroix
Oil on canvas, 1826–30
86 x 56 inches (218 x 144 cm)
Acquired 1895, in exchange for three
of his pastels worth 12,000 francs

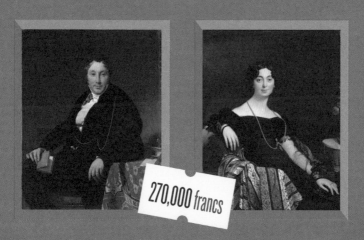

270,000 francs

▲ *Jacques-Louis Leblanc and Madame Jacques-Louis Leblanc*
Jean-Auguste-Dominique Ingres
Oil on canvas, 1823
48 x 38 inches (121 x 96 cm) and 47 x 37 inches (119 x 93 cm)
Purchased 1896, 3,500 and 7,500 francs

WORLD

'WOMEN'S WORK': LAUNDRESSES

Degas's central theme was the working-class women of Paris whose lives were far removed from the bourgeois ladies of his own class. He was fascinated with rendering their movement, dress and physicality alongside the intricacies, skills and sufferings of their labour.

Laundresses were a preferred subject. There were a few industrial laundries by the end of the 19th century, but most were small scale with between one and four workers who lived and worked in harsh conditions, enduring long working hours, disease, alcoholism and poor pay.

What was life like for a laundress in 19th century Paris?

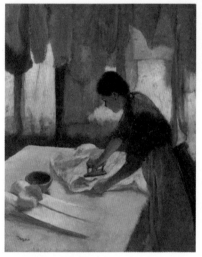

▲ *Woman Ironing*
Edgar Degas
Oil on canvas, c. 1876–87
32 x 26 inches (81 x 66 cm)

THE WORKING DAY:

Laundresses could rise at 5am and labour until 11pm, working an average of 15–18 hours per day. A law passed in 1900 which fixed a 10-hour day for all women and children under 18, though this was not always observed in smaller establishments.

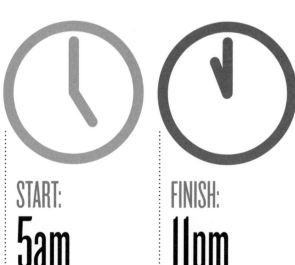

= Hours worked per day

START: 5am

FINISH: 11pm

AVERAGE WAGE PER DAY IN 1881:

Cotton-spinning factory owner:
5,000 francs

Doctor:
20 francs

Embroiderers:
4.25 francs

Milliner/ Women's tailor:
7 francs

Matchmaker/ Candlemaker:
1.50 francs

Seamstress:
2 francs

Lacemaker:
3 francs

Laundress:
3.25 francs

CONDITIONS

Laundresses could suffer severe burns and the stifling conditions incubated disease. Coupled with chemical inhalation this could lead to bronchitis, tuberculosis and inflammation of the abdomen and throat.

90%
of laundresses lived in two rooms; one where they worked, the other where they slept.

Average weight of iron:
5lb
wielded in intolerable heat

Washerwomen walked long distances with up to
20lbs
of linen balanced on their hips

THE RISE OF THE RACES

The 'sport of kings' was imported to France from Britain in the late 18th century, flourishing during the July Monarchy (1830–48) when the relationship between Britain and France thawed. The ascendancy of horse racing runs alongside Degas's own rise as an artist, with the sport becoming one the primary subjects of his work. Several of France's premier racecourses surrounded Paris, with the Champ de Mars at the city's heart. The modest entrance fees attracted all classes and attendance was one of the most popular spectacles of modern life.

1775
A race held at the plain of Sablons, attended by the royal family and court north-west of Paris. It is considered the first true horse race in France.

1776
First racetrack or 'hippodrome' is inaugurated at the plain of Sablons. First races are held at Fontainebleau.

1781
Inauguration of a race course in Vincennes, on the outskirts of Paris.

1796
After the revolution, horse racing makes a comeback on the Champ de Mars in central Paris.

1806
The Champ de Mars racecourse officially opens.

1826
The predecessor of the French Jockey Club is founded.

1828
First stud book is established in France.

1834
Chantilly racecourse opens, becoming the home of the French Jockey Club. The Grand Prix Royal race is established at the Champ de Mars.

1836
Derby de Chantilly – the equivalent of Britain's Epsom Derby – is held for the first time.

1857
Longchamp opens, becoming France's premier racecourse.

1863
First Grand Prix de Paris is run at Longchamp.

EDGAR
DEGAS

03
WORK

"DRAW A LOT. OH! THE BEAUTY OF DRAWING!"

—Edgar Degas, Notebook No. 23, p.45, used between 1868 and 1872

MEDIUMS

Degas was a great experimenter and relished trying out new techniques and mediums – the main ones are shown here, with approximate dates. Drawing in graphite, charcoal and chalk was the basis of his work. When working with oil he occasionally drained it, mixing it with turpentine to create freely flowing 'essence', and often overlaid mediums to great effect. When his vision deteriorated he almost entirely abandoned oil in favour of pastel, and he also turned to sculpture.

▲ **Study of a Dancer Scratching Her Back**
Edgar Degas
Charcoal and white chalk, 1874

BORN 1834 1840 1850 1860 1870

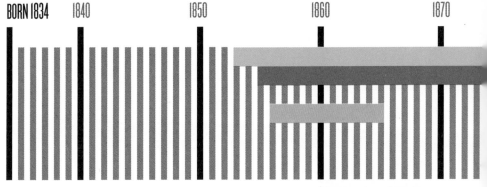

● Drawing (1853–1910)

● Oil (1855–1900)

● Pastel (1875–1907)

● Etching (1856–65) and (1875–92)

● Monotype (1874–86) and (1890–3)

● Photography (1895–6)

● Sculpture (1880–1910)

▲ **Mary Cassatt at the Louvre: The Etruscan Gallery**
Edgar Degas
Soft-ground etching, drypoint, aquatint, 1879–80
11 x 9 inches (26 x 24 cm)

▲ *Madame Camus*
Edgar Degas
Oil on canvas, 1869–70
29 x 36 inches (73 x 92 cm)

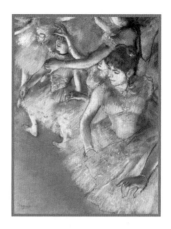

▲ *Ballet Dancers on the Stage*
Edgar Degas
Pastel on paper, 1883
24 x 19 inches (62 x 47 cm)

1880 1890 1900 1910 **DIED 1917**

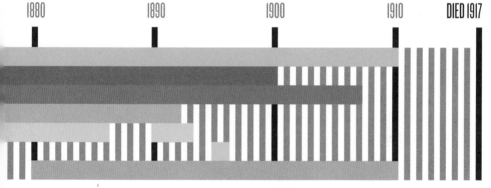

▲ *The Road (La route)*
Edgar Degas
Monotype on china
paper, c. 1878/80
6 x 7 inches (16 x 18 cm)

▲ *Portrait of Ludovic
Halévy*
Edgar Degas
Gelatin silver print,
1895, 3 x 3 inches
(8 x 8 cm)

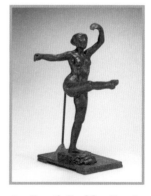

▲ *Fourth Position Front,
on the Left Leg*
Edgar Degas
Beeswax, metal on
wooden base, c. 1885/90

WORK

55

SPHERES OF INFLUENCE

REALISM

Led by Courbet in France, Realism emerged in the mid-19th century in opposition to Romanticism. Realist artists focused on everyday subjects rather than historical or imagined scenes, with an emphasis on line and detail.

Young Ladies of the Village
Gustave Courbet, 1851–2

NEOCLASSICISM

Popular during the 18th century, Neoclassicism drew inspiration from Ancient Greece and Rome. Degas made many copies after Classical works and his idol Ingres spearheaded the late Neoclassical art movement.

Madame Jacques-Louis Leblanc
Jean-Auguste-Dominique Ingres, 1823

MODERN LIFE

Degas gave up painting historical scenes in c. 1865 and instead took inspiration from the rapidly changing world he saw around him: activities of urban leisure such as horse racing, café-concerts, the ballet and working women.

The Englishman at the Moulin Rouge
Henri de Toulouse-Lautrec, 1892

PHOTOGRAPHY

Degas grew up alongside the medium of photography and Eadweard Muybridge's studies of animal locomotion in 1877–8 were particularly influential. Many of his paintings emulate a frozen moment in time.

Attitudes of Animals in Motion
Eadweard Muybridge, 1878–9

JAPANESE PRINTS

Degas was an avid collector of Japanese *Ukiyo-e* ('pictures of the floating world') and appropriated their asymmetrical compositions, bold linework, inventive use of cropping and unusual viewpoints.

The Great Wave off Kanagawa
Katsushika Hokusai, 1830–2

ROMANTICISM

Opposing Realism, Romantic painters focused on the individual and the exotic. The emotions and the imagination were expressed through colour and looser brushwork. Eugène Delacroix was the chief proponent in early 19th-century France.

The Abduction of Rebecca
Eugène Delacroix, 1846

THE RENAISSANCE

Degas revered the masters of the Renaissance such as Raphael, Leonardo, Titian and Michelangelo. He started his career copying their work in the Louvre, and while in Italy he emulated them in his early works.

Madonna and Child
Titian, c. 1508

700 COPIES OF OTHER WORKS PRODUCED BY DEGAS 1856–60

BETWEEN 1853 AND 1873 HALF OF DEGAS'S OUTPUT
INVOLVED PORTRAITURE

BIOGRAPHIC THE BELLELLI FAMILY

Also known as *Family Portrait*, this large-scale work is considered to be Degas's earliest masterpiece and depicts his aunt Laura, her husband Baron Gennaro Bellelli, and their daughters Giulia and Giovanna. Degas stayed with the family, who were living in exile in Florence, during his time in Italy. The painting brilliantly captures the tension and dysfunction of their relationships, particularly through the pyramidal composition of the female subjects and the isolation of the father and husband.

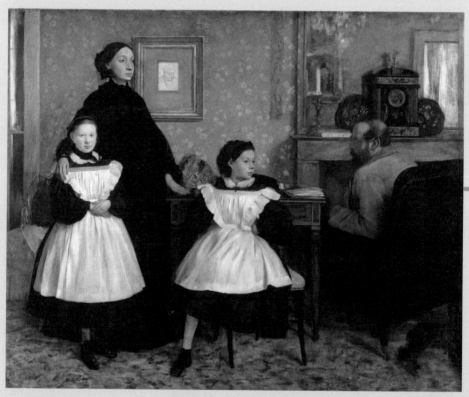

▲ *The Bellelli Family*
Edgar Degas
Oil on canvas, 1858–67,
79 x 98 inches
(200 x 250 cm)

The family dog is seen escaping the scene in the bottom right corner, "sneaking out of the picture before all hell breaks loose," according to critic Arthur Danto.

Laura and her daughters are dressed in black, mourning the death of their father and grandfather Hilaire, who is shown in the red chalk portrait hanging on the wall. Gennaro in contrast is dressed casually.

1858

The year Degas began work on the painting, via preparatory works in a range of media, such as the sketch of Giulia (right). When it was completed is unclear.

1867

The year the painting was shown at the Salon. Degas kept it with him until his last move in 1913.

▲ *Giulia Bellelli*
Edgar Degas
Essence and graphite on paper, c. 1858–9
14 x 10 inches
(36 x 25 cm)

Degas includes a mirror, doorway and window to open the space and hint at a deeper psychological context.

SIZE:
79 X 100 INCHES
(200 X 253 CM)

400,000
FRANCS

The amount paid by the Musée de Luxembourg when the painting was sold in 1918.

"LIVING WITH GENNARO, BY CONTRAST, WHOSE DETESTABLE NATURE YOU KNOW AND WHO HAS NO SERIOUS OCCUPATION, SHALL SOON LEAD ME TO THE GRAVE."

—Laura Bellelli, letter to Edgar Degas, 1860

DEGAS PRODUCED AN ESTIMATED 1,500
STUDIES OF BALLET DANCERS

 = 10
studies

BIOGRAPHIC
THE BALLET CLASS

This painting, along with its companion work, is perhaps the most ambitious of all of Degas's portrayal of dancers. It depicts a dance class coming to an end, with trainee ballerinas shown under instruction, waiting, scratching and stretching. In gaining access to the rehearsal rooms and the backstage of the Opera, Degas was the only artist to represent dancers in their more private moments. The complex composition of this piece – with the dancer in the foreground turning her back to the viewer – allows us to feel that we, too, are witnesses to the lesson.

▼ *The Ballet Class*
Edgar Degas
Oil on canvas, 1871–4
33 x 30 inches (85 x 75 cm)

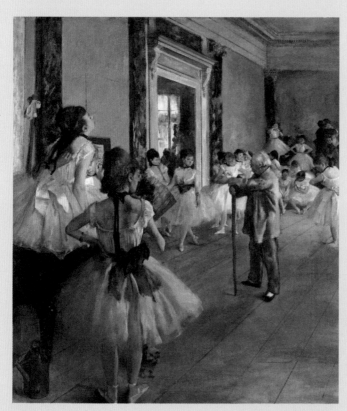

The teacher is the legendary ballet master Jules Perrot, an acquaintance of Degas, shown with his baton – with which he beat time on the floor.

THE SETTING

The setting is the Salle de Peletier, home to the Paris Opera from 1821 until it was destroyed by fire in October 1873 and replaced by the Palais Garnier.

17

The number of dancers in the painting. These are 'petit rats' – students who largely joined the ballet as a way out of poverty in the hope of becoming a first ballerina. You can see some of their mothers in the background, watching and consoling their daughters.

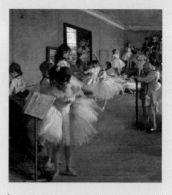

200

The number of individuals in the permanent corps of the Opera ballet.

COMPANION PIECE

The painting has a variant, *The Dance Class* (above), 1874. Commissioned for the singer Jean-Baptiste Faure, it is located in the Metropolitan Museum of Art, New York.

SIZE:
33 X 30 INCHES
(85 X 75 CM)

> "PEOPLE CALL ME THE PAINTER OF DANCING GIRLS. IT HAS NEVER OCCURRED TO THEM THAT MY CHIEF INTEREST IN DANCERS LIES IN RENDERING MOVEMENT AND PAINTING PRETTY CLOTHES."

—Degas, quoted in *Degas: An Intimate Portrait* by Ambroise Vollard, 1927

VENN DEGAS

ENJOYED PAINTING
OUTSIDE "EN PLEIN AIR"

SPONTANEOUS

PAINTED DIRECTLY
FROM LIFE

FOCUS ON COLOUR

PREFERENCE FOR
NATURAL LIGHT

IMPRESSIONISTS

CANDID POSES

VIVID COLOURS

VISIBLE
BRUSH STROKES

The Promenade, or
Woman with a Parasol
Claude Monet
Oil on canvas, 1875
39 x 32 inches (100 x 81 cm)
▼

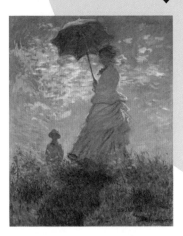

"WHAT A PITY WE ALLOWED
OURSELVES TO BE CALLED
IMPRESSIONISTS"

—Edgar Degas, to
Impressionist painter
Armand Guillaumin, 1907

"NO ART COULD BE LESS SPONTANEOUS THAN MINE"

—Edgar Degas, quoted in *Impressions and Opinions* by George Moore, 1891

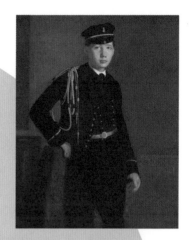

▲

Achille De Gas in the Uniform of a Cadet
Edgar Degas
Oil on canvas, 1856/57
25 x 18 inches (64 x 46 cm)

ASYMMETRICAL COMPOSITIONS

MODERN LIFE AS SUBJECT

CAPTURED MOVEMENT

DEGAS

PREFERENCE FOR PAINTING IN THE STUDIO

METICULOUS PLANNING

PAINTED FROM STUDIES OR FROM MEMORY

FOCUS ON LINE

PREFERENCE FOR ARTIFICIAL LIGHT

BIOGRAPHIC L'ABSINTHE

Absinthe was hugely popular in late 19th century France, beloved by bohemians and rousing the ire of conservative society. *L'Absinthe* divided opinion but was largely denounced as degenerate. It was held up by the temperance movement as a warning against the moral decay caused by alcohol. *L'Absinthe* is a study in sadness and the modern condition of social isolation, absinthe being used to escape from drudgery.

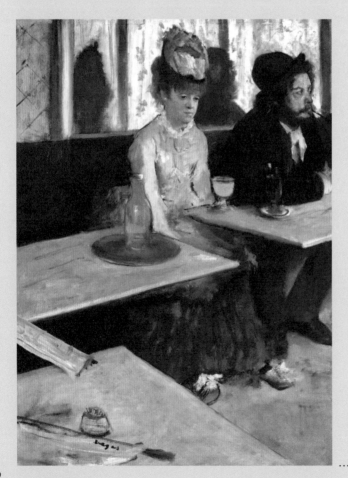

6

The number of titles the painting has been known by. Originally exhibited as *A Sketch in a French Café*, it has also been called *Figures at Café*, *In a Cafe*, *The Absinthe Drinkers*, *Glass of Absinthe*, and finally *L'Absinthe*, 17 years after its completion.

▲ *L'Absinthe*
Edgar Degas
Oil on canvas, 1875–6
36 x 27 inches (92 x 68 cm)

THE MODELS

The woman is Ellen Andrée, an actress and Impressionist muse also seen drinking in *Plum Brandy* by Manet (1877) and *Luncheon of the Boating Party* by Renoir (1880–1). The male patron is Marcellin Desboutin, a portrait painter and printmaker also portrayed by Manet in *L'Artist* (1875). Both found their reputations in tatters and Degas had to step in to publicly announce they were not alcoholics.

"HEAVENS! WHAT A SLUT! A LIFE OF IDLENESS AND LOW VICE IS UPON HER FACE; WE READ THERE HER WHOLE LIFE. THE TALE IS NOT A PLEASANT ONE, BUT IT IS A LESSON."

—George Moore, *Speaker*, 25 February 1893

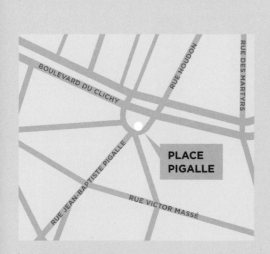

BOULEVARD DU CLICHY
RUE HOUDON
RUE DES MARTYRS
RUE JEAN-BAPTISTE PIGALLE
RUE VICTOR MASSÉ

PLACE PIGALLE

SIZE:
36 X 27 INCHES (92 X 68 CM)

16

The number of years the painting would remain out of the public eye following its scandalous debut in 1876. It was once again met with a chorus of boos when exhibited in 1892 and 1893.

THE SETTING

The setting is the Café de la Nouvelle Athènes on place Pigalle, Montmartre: a bohemian hangout of Degas, Camille Pissarro, Georges Seurat and other avant-garde artists and thinkers.

WORK

69

A LOVE OF COLOUR

Though at the start of his career Degas's palette was dark and reminiscent of Dutch painting, he would soon begin a love affair with colour that is hinted at in his early work *Young Woman with Ibis*. As he grew older and his eyesight started to fail him, the more vivid his colour choices would become.

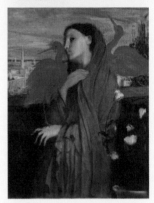

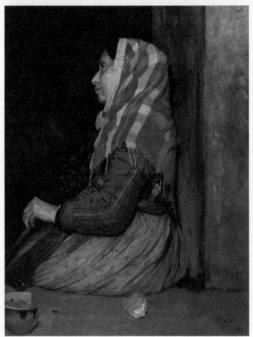

Young Woman with Ibis
Edgar Degas
Oil on canvas, 1860–2
39 x 30 inches (100 x 75 cm)

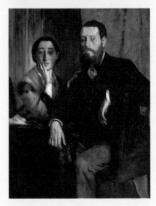

A Roman Beggar Woman
Edgar Degas
Oil on Canvas, 1857
39 x 30 inches (100 x 75 cm)

***Edmondo and
Thérèse Morbilli***
Edgar Degas
Oil on canvas, c. 1865
46 x 35 inches (117 x 90 cm)

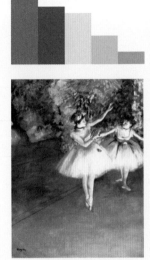

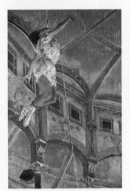

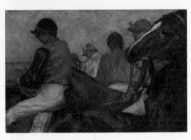

The Jockeys
Edgar Degas
Oil on canvas, c. 1882
10 x 16 inches (26 x 40 cm)

Two Dancers on a Stage
Edgar Degas
Oil on canvas, 1874
24 x 18 inches
(62 x 46 cm)

**Miss La La at
the Cirque Fernando**
Edgar Degas
Oil on canvas, 1879
46 x 31 inches (117 x 78 cm)

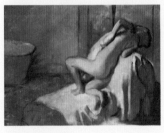

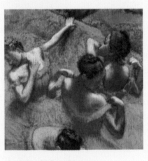

**After the Bath
(Woman Drying Herself)**
Edgar Degas
Oil on canvas, c. 1896
35 x 46 inches (90 x 117 cm)

**Behind the Scenes
(The Blue Dancers)**
Edgar Degas
Pastel on paper, c. 1898
26 x 26 inches (65 x 65 cm)

At the Milliner's
Edgar Degas
Pastel on tracing paper,
c. 1905–10, 36 x 30
inches (91 x 75 cm)

EDGAR DEGAS

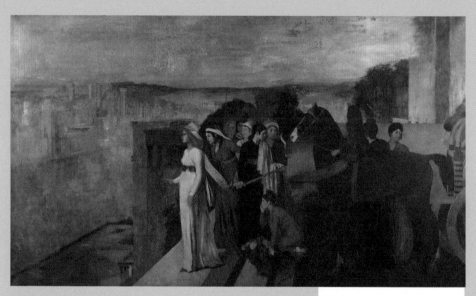

Semiramis Building Babylon
Edgar Degas
Oil on canvas, 1861
59 x 101 inches (151 x 258 cm)

HISTORY PAINTING

SUBJECT:
Mythological: the queen of Assyria, Semiramis, stands on the banks of the Euphrates River, contemplating the building of Babylon. Degas produced several historical paintings at the start of his career, hoping to find favour with the Salon.

TECHNIQUE:
Precise naturalist rendering of line, form and surface, after the Old Masters.

PALETTE:
Muted and sombre.

COMPOSITION:
Traditional: the figures are shown in full and occupy the centre of the painting, with conventional perspective.

DEGAS

LATE WORK

Comparing two works from the opposite ends of his career, we can see Degas's evolution in terms of his style, subject, technique and approach to colour.

SUBJECT:
Contemporary: a trio of ballet dancers wait in the wings, poised between rest and movement. The ballet became Degas's primary subject as he turned away from history painting to depict scenes from modern life.

TECHNIQUE:
Energetic parallel strokes of pastel, heading towards abstraction.

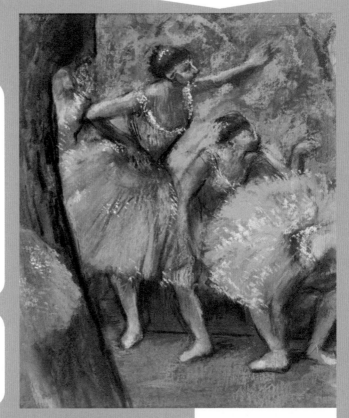

The Dancers
Edgar Degas
Pastel on paper, 1898
29 x 24 inches (74 x 61 cm)

IMPRESSIONISM

PALETTE:
Vivid, highlighted by bright white.

COMPOSITION:
Asymmetric: one of the dancers has been truncated and the prop tree in the foreground serves to frame the trio.

WORK

MATERIAL GIRL

As Edgar's eyesight failed, he turned to the tactile medium of sculpture as a means of rendering form and movement. Just one of these, *Little Dancer Aged Fourteen*, was exhibited during his lifetime. It received a hostile reception when it was first shown in the Sixth Impressionist Exhibition of 1881 and was denounced by many critics as ugly for its realism. Degas used a variety of unorthodox materials in its complex construction: what was it made from?

EXTERIOR

KEY

- Human hair
- Silk ribbons
- Zinc buttons
- Cotton
- Silk and cotton
- Beeswax
- Linen
- Wood

Little Dancer Aged Fourteen
Edgar Degas
1878–81

INTERIOR

KEY

- Wax
- Clay
- Rope
- Organic material (padding)
- Thin wire
- Thick wire
- Paint brushes
- Wood
- Organic material over wood
- Metal armature

300 MONOTYPES

Created by drawing in ink on a metal plate then transferring onto paper – either by hand or by running through a press – a monotype usually results in a single impression. Degas was fascinated by the process and made around 300, becoming the greatest practitioner and innovator of the medium in the 19th century. The majority were rendered in black and white, sometimes overlaid with pastel, though he later experimented with coloured oil paint instead of ink. He reportedly claimed to be the inventor of what he called 'painted drawings'.

1648

The monotype process is invented by Italian artist Giovanni Benedetto Castiglioni.

1874

Degas's friend Ludovic Lepic introduces him to the process, and they collaborate on several of his early monotypes.

1890

A trip to Burgundy inspires his first landscape monotypes in coloured oil paint, verging on abstraction.

2016

MoMA, New York City, stages the exhibition *A Strange New Beauty*, the first American exhibition of Degas's monotypes in 50 years.

1958–60

Pablo Picasso acquires nine monotypes by Degas representing scenes in brothels. He considers them to be among his best work.

◀ ***Woman by a Fireplace***
Edgar Degas
Monotype
1880/90
13 x 19 inches
(33 x 49 cm)

DEGAS

EDGAR
DEGAS

04
LEGACY

"AS A MAN AND PAINTER HE SETS AN EXAMPLE. DEGAS IS ONE OF THOSE RARE MASTERS WHO COULD HAVE HAD ANYTHING HE WANTED, YET HE SCORNED DECORATIONS, HONORS, FORTUNE, WITHOUT BITTERNESS, WITHOUT JEALOUSY."

—Paul Gauguin, *Avant et après*, 1903

CRITICAL RECEPTION

Degas received exulted praise but also harsh criticism during his lifetime, with his choice of lower-class subjects bringing him the most disapproval. He was also capable of dishing out his own caustic quips, once saying to Monet in reference to his painting: "Let me get out of here. Those reflections in the water hurt my eyes!" Agonizingly self-critical, when an exhibition review commented that he was "continually uncertain about proportions" he agreed, claiming that it perfectly described his process as an artist.

"NO ONE CAN EXPRESS WITH A SURER HAND THE FEELING OF MODERN ELEGANCE ... MOREOVER, THIS IS A MAN WHOSE CAPACITY FOR OBSERVATION, ARTISTIC SUBTLETY, AND TASTE REVEAL THEMSELVES IN EVEN HIS SMALLEST WORKS."

—**Philippe Burty, *La Republique Francaise*, 25 April 1874**

"AS IN PREVIOUS YEARS, DEGAS REMAINS THE INCONTESTABLE AND UNCONTESTED MASTER ... EVERYTHING IS SO INTERESTING THAT IT IS HARD TO PRAISE IT AGAIN WITHOUT REPEATING ONESELF."

—**Paul-Armand Silvestre, *La Vie Moderne*, 24 April 1880**

"A PAINTER OF MODERN LIFE WAS BORN, AND A PAINTER WHO DERIVED FROM NO ONE, WHO RESEMBLED NO ONE ELSE, WHO BROUGHT A TOTALLY NEW FLAVOUR TO ART, TOTALLY NEW PROCEDURES OF EXECUTION."

—**J.K. Huysmans, *L'Art Moderne*, 1883**

"M. DEGAS IS STILL OBSESSED WITH MOVEMENT—HE PURSUES IT TO THE POINT OF VIOLENT, DISGRACEFUL CONTORTION. THIS OBSTINACY IN ONE KIND OF IDEA HAD TO LEAD TO THIS ..."

—Eugène Véron, *L'Art*, 1880

"HE WILL NEVER CHANGE; WE WILL NEVER HAVE FROM HIM ANYTHING BUT DANCERS AT WORK, LIGHT FALLING BIZARRELY FROM LOW WINDOWS, STEEPLY SLOPING FLOORBOARD WITHOUT ANY PERSPECTIVE ..."

—Arthur Baignères, *La chronique des arts et de la curiosité*, 1880

"MONSIEUR DEGAS IS A CRUEL PAINTER ... HE KNOWS ALL THE SCARS OF PRECOCIOUS VICE; HE HAS A FEELING FOR DISGUISED HIDEOUSNESS ... M. DEGAS'S COMPOSITIONS ARE SPARSE AND DISORDERED ... HIS TALENT INCLUDES SOME NEGLIGENCES WHICH ARE PERHAPS ARTIFICE; M. DEGAS ABOUNDS IN IRRITATING PARADOXES."

—Paul Mantz, *Le Temps*, 1877

Since his death, Degas's legacy has been mixed: he is recognized as one of the most influential of the Impressionist artists and the most talented draughtsman of his generation, but some modern critics have commented that there are misogynistic undertones to his work and his anti-Semitism has served to alienate him from some audiences.

DEGAS'S PLACE IN ART

MICHELANGELO
1475–1564 (Italian)

TITIAN
1488–1576 (Venetian)

RAPHAEL
1483–1520 (Italian)

NICOLAS POUSSIN
1594–1665 (French)

PETER PAUL RUBENS
1577–1640 (Flemish)

JACQUES-LOUIS DAVID
1748–1825 (French)

EUGÈNE DELACROIX
1798–1863 (French)

JEAN-AUGUSTE-DOMINIQUE INGRES
1780–1867 (French)

EDGAR DEGAS
1834–1917

WALTER SICKERT
1860–1942 (English)

PAUL GAUGUIN
1848–1903 (French)

PABLO PICASSO
1881–1973 (Spanish)

PAUL CÉZANNE
1839–1906 (French)

TINTORETTO
1519–1594 (Venetian)

DIEGO VELÁZQUEZ
1599–1660 (Spanish)

REMBRANDT VAN RIJN
1606–69 (Dutch)

FRANCISCO DE GOYA
1746–1828 (Spanish)

GUSTAVE COURBET
1819–77 (French)

JEAN-BAPTISTE-CAMILLE COROT
1796–1875 (French)

PAUL GAVARNI
1804–66 (French)

HONORÉ DAUMIER
1808–79 (French)

ÉDOUARD MANET
1832–83 (French)

HENRI DE TOULOUSE-LAUTREC
1864–1901 (French)

VINCENT VAN GOGH
1853–90 (Dutch)

HENRI MATISSE
1869–1954 (French)

KEY

- High Renaissance
- Baroque
- Dutch Golden Age
- Neoclassicism
- Romanticism
- Realism
- Impressionism
- Post-Impressionism
- Primitivism
- Camden Town Group
- Surrealism
- Cubism
- Fauvism

LEGACY

DISCOVERING THE SCULPTOR

Little Dancer Aged Fourteen was the only sculpture exhibited during Degas's lifetime. When he died, 150 models made from wax, clay and plastiline were discovered in his studio, though the perishable nature of their materials meant only around half could be posthumously cast in bronze by the early 1920s. The sculptures depicted dancers, nudes and horses influenced by the animal motion studies of the photographer Eadweard Muybridge. It's probable that they were never meant for public eyes, and that Degas used them solely to explore his favourite themes.

Horse Galloping on the Right Foot
Brown wax and cork, 1880s
13 x 17 x 9 inches
(33 x 43 x 23 cm)

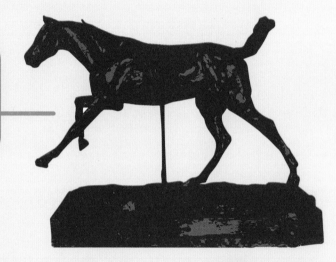

Grande Arabesque
Bronze, modelled c. 1885–90, cast c. 1920
17 x 24 x 12 inches
(43 x 60 x 31 cm)

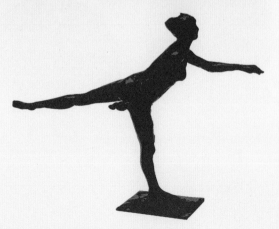

Sculpture exhibited in Degas's lifetime, later cast in bronze

Sculptures discovered after death, later cast in bronze

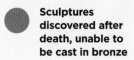
Sculptures discovered after death, unable to be cast in bronze

TYPOGRAPHIC DEGAS

draughtsman

ballet

line

form

Ingres

oil

unmarried

alone

sculpture

Italy

opera

New Orleans

Degas

colour

Paris

portrait

bourgeois

9th arrondissement

etching

Montmarte

Hilaire

Realism

Salon

Japanese prints

history painting

Renaissance

racehorse

milliner

movement

laundress

Dreyfus

nude

bathing

Musée D'Orsay

Louvre

eyesight

Impressionism

collector

café

Great Masters

pastel

dancer

drawing

monotype

Neoclassicism

women

cotton

absinthe

UNDER THE HAMMER
IMPRESSIONISTS AT AUCTION

Danseuse au Repos
Edgar Degas
Pastel and gouache on joined
paper, c. 1879
23 x 25 inches (59 x 64 cm)

$300m
When Will You Marry?
Paul Gauguin
1892, sold 2015

$259m
The Card Players
Paul Cézanne
1892–3, sold 2012

$80.5m
Les Bassins aux Nymphéas
Claude Monet
1919, sold 2008

$78.1m
Bal du Moulin de la Galette
Pierre-Auguste Renoir
1876, sold 1990

$65.1m
Jeanne (Spring)
Édouard Manet
1881, sold 2014

$37m
Danseuse au Repos
Edgar Degas
c. 1879, sold 2008

$32m
Le Boulevard Montmartre,
Matinee De Printemps
Camille Pissarro 1897, sold 2014

$18m
Le Pont d'Argenteuil et la Seine
Gustave Caillebotte
1885, sold 2011

$10.9m
Après le déjeuner
Berthe Morisot
1881, Sold 2013

$4.25m
Le Loing à Moret
Alfred Sisley
1886, sold 2007

LEGACY

**The Metropolitan Museum of Art,
New York City**
23 PAINTINGS
Including *The Dance Class*, 1874

**National Gallery of Art,
Washington, DC**
21 PAINTINGS
Including *The Races*, 1871–2

**Norton Simon Museum,
Pasadena**
10 PAINTINGS
Including *The Laundress*, c. 1873

**Yale University Art Gallery,
New Haven**
6 PAINTINGS
Including *The Jockeys*, c. 1882

**Detroit Institute of Arts,
Detroit**
6 PAINTINGS
Including *Dancers in the Green
Room*, c. 1879

**Art Institute of Chicago,
Chicago**
7 PAINTINGS
Including *Café Singer*, 1879

**J. Paul Getty Museum,
Los Angeles**
4 PAINTINGS
Including *Self-Portrait*, 1857–8

**Brooklyn Museum,
New York City**
3 PAINTINGS
Including *Portrait of Mlle Fiocre in
the Ballet 'La Source'*, 1867–8

**Philadelphia Museum of Art,
Philadelphia**
4 PAINTINGS
Including *After the Bath
(Woman Drying Herself)*, c. 1896

LOCATING DEGAS

Degas's artwork is represented in more than 150 museums and galleries worldwide. The Louvre accepted 20 works in 1911 (usually a posthumous honour), with further works purchased after his death. In the late 20th century these were transferred to the Musée d'Orsay, which houses the largest collection of Degas's work in the world.

The numbers given here relate to paintings in permanent collections only, but there are many more pastels, drawings, monotypes, photographs and works in other media in existence to explore, as well as regular temporary exhibitions.

CANADA

**National Gallery of Canada,
Ottowa**
4 PAINTINGS
Including *At the Café-concert*,
c. 1879–84

UNITED KINGDOM

**The National Gallery,
London**
9 PAINTINGS
Including *Combing the Hair
(La Coiffure)*, c. 1896

**The Fitzwilliam Museum,
Cambridge**
5 PAINTINGS
Including: *Au Café*, c. 1875–7

**Scottish National Gallery,
Edinburgh**
3 PAINTINGS
Including *Diego Martelli*, 1879

**Birmingham Museum & Art Gallery,
Birmingham**
1 PAINTING
A Roman Beggar Woman, 1857

FRANCE

**Museé d'Orsay,
Paris**
43 PAINTINGS
Including *The Bellelli Family*, 1858–67

GERMANY

**Neue Pinakothek,
Munich**
2 PAINTINGS
Including *Woman Ironing*, 1869

SWITZERLAND

**Foundation E.G. Bührle Collection,
Zurich**
4 PAINTINGS
Including *Ludovic Lepic and
His Daughters*, c. 1871

SPAIN

**Museo Thyssen-Bornemisza,
Madrid**
1 PAINTING
The Pond in the Forest, 1867–8

AUSTRALIA

**National Gallery of Australia,
Canberra**
1 PAINTING
*A Nanny in the Luxembourg Gardens,
Paris*, c. 1875

BIOGRAPHIES

**René De Gas
(1845–1921)**
Edgar's youngest brother.
They travelled together to New
Orleans, where René was living,
in 1872. The two fell out later
but were reconciled. Degas
made several studies of René
and his wife – their cousin
Estelle Musson.

**Mary Cassatt
(1844–1926)**
American Impressionist artist
who formed a close friendship
with Degas. He admired and
encouraged her talent and
bought several of her works; she
sat for several of his paintings,
drawings and etchings.

**Ludovic Halévy
(1834–1908)**
Childhood friend, author,
playwright and librettist who,
with his wife Louise, provided a
second home for Degas. Ludovic
would remain one of Degas's
closest acquaintances until
they were estranged by the
Dreyfus Affair.

**Paul Durand-Ruel
(1831–1922)**
Leading art dealer and
advocate of the Impressionist
artists. Degas furnished Durand-
Ruel with a regular supply of
work to sell in return for a
reliable stream of money,
released as and when he
needed it.

**Ludovic Lepic
(1839–89)**
Lepic was a count, patron of
the arts and amateur painter
who showed work in the first
two Impressionist exhibitions.
Crucially, he introduced Degas to
the medium of monotype and
is the subject of 11 of Degas's
paintings and pastels.

**James Tissot
(1836–1902)**
Popular French genre
painter who emigrated to
England in the 1870s. They
studied together under Louis
Lamothe and enjoyed a close
friendship, with a wealth of
correspondence, particularly
when Degas was in New
Orleans.

Henri Rouart (1833–1912)

The two met at school and they would remain lifelong friends until Rouart's death in 1912. They served in the same unit during the Franco-Prussian War. Henri became a wealthy industrialist who bought several of Degas's works.

Paul Valpinçon (1834–94)

Degas and Valpinçon were friends from boyhood. Degas would often spend his summers at the Valpinçons' country estate at Ménil-Hubert, Normandy. Paul was a cousin of Gustave Caillebotte and his father, Édouard, introduced Degas to Ingres in 1855.

Gustave Moreau (1826–98)

Edgar met painter Gustave while in Italy and they had a brief but influential friendship in the late 1850s. Artistically they shared a love of the past, but when Degas turned to modern subjects, Moreau continued on the road to Symbolism.

Ambroise Vollard (1867–1939)

As an important dealer and collector of modern art, Vollard helped to promote Degas's work as well as that of several other artists including Picasso, Gauguin and Cézanne. He wrote the biography *Degas: An Intimate Portrait* in 1924.

Marguerite De Gas (1842–95)

Edgar's youngest sister and reportedly his favourite sibling, Marguerite married the architect Henri Fèvre and moved to Buenos Aires. Their daughter, Jeanne, cared for Degas in his old age.

Paul-Albert Bartholomé (1848–1928)

Bartholomé was one of Degas's closest friends in old age. He was a sculptor and the two encouraged and advised each other in their work. His masterpiece is the *Monuments aux Morts* in the Père Lachaise Cemetery.

● friend ● family

● business associate

INDEX

A

Absinthe, L' 27, 68-9
Achille De Gas in the Uniform of a Cadet 67
After the Bath (Woman Drying Herself) 71, 90
Agnew, Thomas 38
Andrée, Ellen 69
anti-Semitism 10, 30, 31, 32, 81
art collection 46-7
At the Café-concert 91
At the Milliner's 71
Au Café 91
auctions 88-9

B

Baignères, Arthur 81
Ballet Class, The 64-5
ballet dancers 62-3 *see also* individual works
Ballet Dancers on the Stage 55
Bartholomé, Paul-Albert 93
Behind the Scenes (The Blue Dancers) 71
Bellelli, Laura 25, 28, 61
Bellelli Family, The 25, 60-1, 91
Braquemond, Marie 29
Burty, Philippe 80

C

Café de la Nouvelle Athènes, Paris 40, 69
Café Guerbois, Paris 21, 40
Café Singer 90
Caillebotte, Gustave 27, 30, 42
Le Pont d'Argenteuil et la Seine 89
Caron, Rose 29
Cassatt, Mary 27, 28, 29, 31, 34, 42, 54, 92
Castiglioni, Giovanni Benedetto 76

Cézanne, Paul 30, 33, 42, 82
The Card Players 89
childhood 14, 20
colour, love of 70-1
Combing the Hair (La Coiffure) 91
copies of other artists' works 58
Cotton Office in New Orleans, A 26, 27, 38-9
Courbet, Gustave 83
Young Ladies of the Village 56
critical reception 80-1

D

Dance Class, The 65, 90
Dancers, The 73
Dancers at the Barre 31
Dancers in the Green Room 90
Danseuse au Repos 44, 88, 89
David and Goliath 25
De Gas, Achille 18, 30, 38
De Gas, Auguste 18, 26
De Gas, Célestine (née Musson) 18, 19, 20, 28
De Gas, Marguerite 19, 28, 30, 93
De Gas, René 19, 26, 38, 92
De Gas, Thérèse 19, 28, 31
death 34
Degas, Hilaire 18, 21, 24, 25
Delacroix, Eugène 30, 46, 82
The Abduction of Rebecca 57
Louis-Auguste Schwiter 47
Desboutin, Marcellin 69
Diego Martelli 91
Dreyfus Affair 9, 30, 31, 32-3
Dumas, Alexander 34
Durand-Ruel, Paul 26, 27, 30, 92

E

early/late work 72-3
École des Beaux-Arts, Paris 20
Edmondo and Thérèse Morbilli 70
Etoile, L' 27
exhibitions 42-3
eye problems 9, 26, 30, 44, 54, 70

F

family tree 18-19
Faure, Jean-Baptiste 65
Fèvre, Jeanne 28, 93
Fischer, Isaac 16
Fourth Position Front, on the Left Leg 55

G

Gauguin, Paul 27, 42, 78, 82
The Day of the God 30
When Will You Marry? 89
Goethem, Marie van 29
Gogh, Vincent van 30, 83
Grande Arabesque 84
Greco, El: *Saint Ildefonso* 47
Guilia Bellelli 61

H

Halévy, Ludovic 9, 31, 55, 92
Halévy family 27, 30
Haussmann, Georges-Eugène 20
Hokusai, Katsushika: *The Great Wave of Kanagawa* 57
Horse Galloping on the Right Foot 84
horse racing 50
Huysmans, J.K. 80

I

Impressionism 26, 73
at auction 88-9
exhibitions 42-3

Ingres, Jean-Auguste-
Dominique 9, 20, 22–3,
27, 46, 82
 The Bather 22, copy by
 Degas 23
 Jacques-Louis Leblanc
 47
 Madame Jacques-Louis
 Leblanc 47, 56
 Self-Portrait at the Age
 of 24 22
Italy 24–5

J
Japanese art 9, 21, 57
Jockeys, The 71, 90

L
Lamothe, Louis 20
Laundress, The 90
laundresses 48–9
Lepic, Ludovic 76, 92
Little Dancer Aged
 Fourteen 27, 74–5, 84
locations of paintings 90–1
Lorrain, Claude 25
Ludovic Lepic and His
 Daughters 91
Lycée Louis-le-Grand,
 Paris 20

M
Madame Camus 26, 55
Manet, Édouard 21, 44, 45,
69, 83
 Jeanne (Spring) 45, 89
Mante, Blanche & Suzanne
29
Mantz, Paul 81
marriage 8, 28
Mary Cassatt at the Louvre:
 The Etruscan Gallery 54
Matisse, Henri 83
mediums, timeline of 54–5
 see also monotypes
Miss La La at the Cirque
 Fernando 27, 71
Monet, Claude 8, 14, 21, 29,
32, 34, 42, 80
 Les Bassins aux
 Nymphéas 89
 The Promenade,
 or Woman with a

Parasol 66
monotypes 54, 55, 76
Montmartre Cemetery
 34, 40
Moore, George 69
Moreau, Gustave 25, 34, 93
Morisot, Berthe 29, 42
 Après le déjeuner 89
Musson, Estelle 28
Muybridge, Eadweard 84
 Attitude of Animals in
 Motion 57

N
Nanny in the Luxembourg
 Gardens, Paris, A 91
Neoclassicism 56
Neyt, Sabine 29

P
Paris 14, 16, 26, 40–1
Perrot, Jules 64
photography 54, 55, 57
Picasso, Pablo 76, 82
Pissarro, Camille 32, 42
 Le Boulevard Montmartre
 Matinee De Printemps 89
place in art 82–3
Pond in the Forest, The 91
Portrait of Ludovic Halévy
 55
Portrait of Mlle Fiocre in
 the Ballet 'La Source'
 21, 90
Portrait of the Artist 23
Portraits at the Stock
 Exchange 27
Proust, Marcel 32

R
Races, The 90
Realism 56
Renaissance 57
Renoir, Pierre-Auguste 8,
21, 42, 69
 Bal du Moulin de la
 Galette 89
Road, The (La Route) 55
Roman Beggar Woman, A
 25, 70, 91
Romanticism 57
Rouart, Henri 26, 31, 33, 93

S
Salon des Refusés 21, 44
Sanlaville, Marie 29
Scene from the
 Steeplechase: The Fallen
 Jockey 21
Scene of War in the Middle
 Ages 21
sculpture 54, 55, 84–5 *see*
 also individual works
Self-Portrait 90
Semiramis Building
 Babylon 72
Sicket, Walter 27, 82
Silvestre, Paul-Armand 80
Sisley, Alfred 42
 Le Loing à Moret 89
slavery 16
Study of Dancer Scratching
 Her Back 53

T
Tissot, James 38, 92
Titian 82
 Madonna and Child 57
Tolpuddle Martyrs 16
Toulouse-Lautrec, Henri
 de 83
 The Englishman at
 the Moulin Rouge 56
Two Dancers on a Stage 71

V
Valadon, Suzanne 29
Valery, Paul 33
Valpinçon, Paul 93
Venn diagram of Degas
 66–7
Véron, Eugène 81
Vollard, Ambroise 34, 65,
 93

W
Woman by a Fireplace 76
Woman Ironing 48, 91
world in 1834 16–17

Y
Young Woman with Ibis 70

Z
Zola, Émile 32

DEGAS'S MEDIUMS

- ● Drawing (1853–1910)
- ● Oil (1855–1900)
- ● Pastel (1875–1907)
- ● Etching (1856–65) and (1875–92)

- ● Monotype (1874–86) and (1890–3)
- ● Photography (1895–6)
- ● Sculpture (1880–1910)

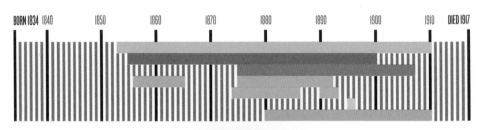

BORN 1834　1840　1850　1860　1870　1880　1890　1900　1910　DIED 1917